48th street

48th street

prose poems and paintings

ann E peck

gatekeeper press™

Columbus, Ohio

48th street: prose poems and paintings
Published by Gatekeeper Press
2167 Stringtown Rd, Suite 109
Columbus, OH 43123-2989
www.GatekeeperPress.com

Library of Congress Control Number: 2020950908

ISBN (hardcover): 9781662906503
eISBN: 9781662906510

CONTENTS

this book is dedicated to
Jon Conte, Ph.D.

and to all of us for whom the truth is important

thank you
Susan Duma, Psy.D., Mark Bloom, Jeff Handelman,
Barbara Berger Ph.D., Sara Connell (my midwife who
helped me birth this book), Katie Kizer, the ever patient
Eden Tuckman from Gatekeeper Press and Johnny

and to all of you who have walked with me, cried with
me, talked to me, listened to me and held my hand
through this journey

you know who you are

I am so grateful for each of you

this is my story

Prologue

1988

It was late morning on a rainy Tuesday.
The perfect day for a daytime movie in a dark theater.

BIG, a new movie starring Tom Hanks, promised to entertain.

Only a smattering of people in the small theater.
Alone in the third row, no one to my right or left.

I was enjoying handfuls of buttered popcorn when it happened.

Tom Hanks, playing a young boy in an adult body, watches his grade school friends having fun on a playground.
He longs to be one of them…to be young.

I knew that feeling.

When I was five years old, I looked at my kindergarten classmates and knew I didn't belong.
I was a grown-up in a little girl's body.

At that moment, in that dark theater, watching BIG, as if white ticker-tape letters marched across the top of the screen, I saw

"YOU WERE SEXUALLY ABUSED AS A CHILD"

I searched for a memory, but it kept darting away.
Shocking news, yet I knew it was true.
The secret I wouldn't let myself know.

Yet.

That moment, that stunning realization, started me on
the painful journey of recovery.
Recovering my memories, recovering myself.
Listening to the voice within me who had lived the story.
The child who fought valiantly to make me see her, hear
her, believe her.

I was 42 the day I saw BIG.
I had 3 young children.
I had been married and divorced 3 times.
I had been sober for 3 years.

I did not know how or where to begin, how to make
sense of this truth that bombarded me, halted me, and
somehow freed me.

Free to paint.
Free to write.
Free to create a CHARMed life.

a fact

the first man i ever met, the first man i ever loved
was a brutal criminal, a pedophile
he was my father

famous

my father was a celebrity to me
i believed he was the whole world

big beyond big
important beyond important

and he chose ME!

we were closer than close
we had secrets
we had plans

never mind what happened at night

look the other way
don't think about it
don't feel it

and in an instant, it was all over
all the fame, the glory, the specialness

in came the solitude

don't think about it
don't feel it

it's over
was it an illusion?
the promise a lie?

what did i do wrong?
turn ugly?
turn bad?

i'm sorry dad

family

the youngest of three children in a family of five
my father's favorite

outcast sister
sickly bedridden brother
depressed mother lost in her library books

i felt beloved
the only "normal" relationship in the family

he promised me a life in a cabin in Colorado, just the two
of us
as soon as i didn't need a mother

when had I needed a mother?
she wasn't there

father

a distinguished man
full head of white hair at 40

three-piece suit and tie every day
casual dress meant suit jacket and tie were removed
thick-lensed foreboding glasses on at all times

smiles, rare

angry aura

powerful force

this man chose ME as his confidant!

on Saturdays he went to the village board meetings with
me at his side
on days off of school, i accompanied him to work and
lunched with lawyers and judges
i was 8

totally unaware of the darkness that enveloped me

a little girl

a partner, a sidekick, his confidant, his favorite
special privileges…only one allowed to sit in the red
leather chair besides him, only one that went with him
on car rides after dinner, accompanied him to his work
meetings

careful in the neighborhood
careful at school
pretend i'm just a little girl

careful when i'm with him
not to be a little girl

annE '2020

rides

after dinner, my father and i went for rides in the Cadillac
he would tell me of our plans to move to Colorado
we would point to houses that we liked and plan our own

he came alive, was happy

we would stop at the News Agency for Krackle bars

before bed, we often shared cough syrup with codeine

later, my mother in my bed
my brother wheezing in his bed
my sister still in her room…never having come down for
dinner

they feared him

me in his bed being asked, "who do you love more, your
mother or me?"
my answer was always the same

first taste

every night, my father offered me sips of beer from his
clear rippled glass
sparkly taste, bubbles going up my nose

"mom was mad at him for that," my sister said once
he had given me too many sips one time
i stumbled when i tried to walk

i was in kindergarten

some nights he offered me some of his cough syrup
"let's have a swig before we go to bed"
it was sweet and syrupy…and full of codeine

beds

i'm in their bed
she's in mine instead

i'm not safe
she is

i got along and went along

i grew up with an older sickly brother and an even older
sister, sullen and alone
i caught on quickly that i didn't want to be who they were

i got along and went along

my sister was exiled early, i never knew why
she was not part of the family, didn't have painfully silent
dinners with us, spent her time in her room at the end of
the hall with its own bathroom
a hideaway

some nights lying in my father's bed i could hear his
voice rise up the back staircase, summoning my brother,
"get down here"
i hear my brother's footsteps creaking on the wooden
stairs

the CRACK as my father pulled out his belt, loop by
loop, the snap of the belt hungry for my brother's skin

i don't hear my brother cry, i'm already gone

i got along and went along

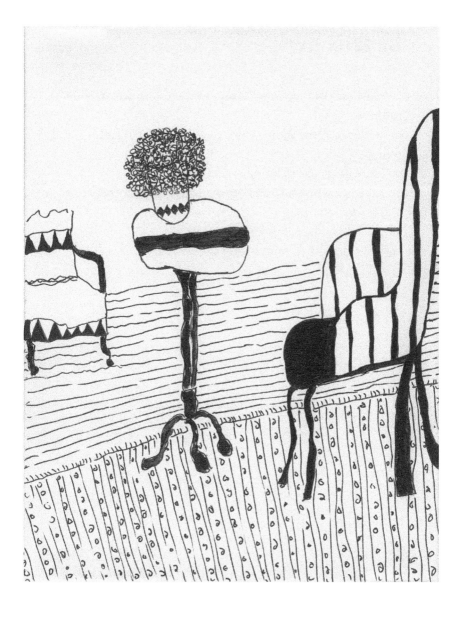

he tells her

he tells her that she's too young to leave, she still needs a
mother
he tells her when she's grown enough they will leave
together,
get a cabin in the mountains of Colorado
he asks her who she loves more, him or her mother?

she tells him she loves him the most
she tells herself to stop loving the mother

kindergarten l

sitting in a circle listening to the teacher read a book,
finger painting,
naps on a rough woven mat
boring
kids my age running, shrieking, laughing, coloring
boring

waiting for the clock to strike noon, waiting to go home
and spend the afternoon longing for my father's 5:00
arrival.

"where's Baby?" he called when he opened the front
door of our massive old frame house on the corner of
main street and 6th avenue

before the exile, i was always "Baby"

post-exile my name was anne and there was silence when
the door opened at 5:00

kindergarten ll

one spring morning, i spilled a large bottle of bright blue
finger paint all over my painting, the table, and onto my
little skirt
it dripped down my legs and soaked my white anklets,
then soaking my shoes

furious with myself for acting like a child
it was important to be "grown up" so my father and i
could leave for Colorado

the teacher called my mother to bring me a change of
clothes

my mother!!!

"*as soon as you don't need a mother we can leave*"
his voice echoed in my head

my mother standing in my classroom, a stack of clean
clothes in her arms

i changed clothes in the cloak room
the cloak room with no door on it!
"hurry!" i said to myself as i stood shivering, hiding
behind a coat in my undershirt, terrified a little boy
would walk in

humiliated

"don't let my father find out"

this would surely set the time back for our escape

he would think i still needed a mother

annE '2020

my mother

absent

where were you?
where did you go?
who/what drove you there?

your absence was felt…
maybe more than your presence would have been

i'll never know

marcella

i only knew you as mother

from a lone female law student in an all-male class
beautiful, brilliant from what pictures show and people
say

a glass framed photo of you dated 1930 leans against my
azure wall
you sitting on a sun-bleached, wide-planked dock
legs tucked under you, long wet hair skimming your
shoulders, deep eyes staring at the camera
beautiful and young

where did you go?

my bike

i had a bad fall off my bike one hot summer day and ran
up the back porch stairs into the kitchen, crying

my mother pulled me on her lap

tears dried, i realized i was on her lap!
i dashed out the back door

if he saw me we'd have to stay

strangers

you birthed me, you bathed me, you burped me

i saw you in your housedress with your head always
buried in one of your books
i saw you always walking so slowly
i saw you, serious, talking on the black rotary phone in
the front hall for what seemed like hours

did you see me?

DISTILLATION

Go back to her entirely. You love her.
I love her, too, nor can I hurt a child.
Yet if you need me, turn and take my heart.
Rest on my love, find here tranquillity
And at the center of your days a place
Of peace. And you shall never know, beloved,
Henceforth I walk alone, companionless,
Your love spread out before me like a land
To which I may not go. I love her, too.

Ladies Home Journal
3/21/50

This is a piece my mother wrote and submitted to Ladies Home
Journal in 1950. It was not published.

nicest

he was nicest to me
i was his favorite
he was nicest to me
i was his princess
he was nicest to me
i felt special
he was nicest to me

then as subtle as the switch of two letters
it went from nicest to incest

religion

catholic schools, mass, benediction, confession,
stations of the cross, knees red on wooden kneelers

my father, a confidant to the monsignor

my mother, beloved by the nuns

rosaries
saints

secrets

so fun to be chosen to keep one

so special, kept close to the heart

secret, prison, burden?
why is it a secret?
because it's a surprise?
a lie?

secrets
bigger before shared or after?

my pajamas

it's a summer night
the windows are open
the thin, lacy curtains are gently moving with the breeze

i don't understand what he's doing
his hand moving rapidly, fast over his body

i lay perfectly still

waiting for my thin cotton yellow summer pajamas with
the bunny print on them to dry
the fabric is wet and sticking to my stomach

after, my father lightly snoring

It was the Best of Times...It was the Worst of Times

Her fantasy was that she was a princess, his favorite...
beloved and safe

Although her feelings were true—that was not the truth
Her reality was that she was an object—owned by a father
with a troubled soul

To endure the nights, she let herself wander away from her
body—kept her own SELF safe from feeling her feelings

She would attach her mind to the faithful radiator who
stood nearby—ever strong and warm, comforting her with
gentle sounds

It was the best of times...it was the worst of times

Her fantasy was that she believed him when he said they
would soon leave together—as soon as she no longer needed
a mother—and live happily in the mountains of Colorado

She enjoyed being his favorite by day—sharing chocolate,
sips of beer, and swigs of codeine cough syrup before bed

Her reality was she was a fragmented 3rd grader who knew
that her nightly duties were never to be spoken of

For decades, this story was either drowned by food, drugs,
and alcohol or it was the only thing that mattered

Now it has its own place—chapters for sure but not the title
of the book

Now she knows it's a part of her CHARMed adult life
A part she can't always remember but will never forget
A part to embrace and comfort when needed
A part whose secrets need to be heard
A part who needs her adult wisdom

Her secrets are safe with HER
SHE is here to help her heal
She is here to tell HER what she needs

When I see the parts of me as bodies of water—I see them
all flowing together
They're merging as one powerfully moving force

Dancing along

triangles

in kindergarten, we struck triangles with metal wands to
make sound
in religion, we met the father, son, and holy ghost
in geometry, isosceles, equilateral, scalene
in traffic, a triangle tells me to yield

as a child, i believed that my father and i were a couple, a
pair, only two
but there was a third, my mother

tv

when Ozzie kissed Harriet on our fancy console
television
my father sprang from his red leather chair and slammed
the off button
"such trash!" he bellowed

what would he call reaching for me at night?

Oh Bill!

My mother walked into the bedroom and saw me
choking and spitting into the feather pillow.
I held the pillow carefully so that I didn't make a mess
anywhere else.
I'd tried to be quiet, but I was gagging and she must have
heard me.

The dream of going to Colorado, our cabin in the
mountains, ended.

"Oh Bill!" was all she gasped. Not a glance at me.

I was escorted out of that room and into my room with
the unfamiliar bed.

Never was a word spoken about that night.
And never again did my father and I have a private
conversation, a special car ride, share a candy bar.

He never again met my eyes.

I had ruined everything!

I spent the rest of his life trying to win him back.

flip of the switch

my mother flipped on the light, Truth illuminated
the rumpled bed, my father exposed
gone the pristine princess, shattered like glass on the
hardwood floor

exile

returned to my room
my room?
no hiss of the radiator, cold white sheets

10 years old, the dream of Colorado dead

after the exile

bright young girl
like a princess
safe and secure in her precious place
next to her father

bright young girl, who felt clean and good

evaporated?
disintegrated?
demolished?
escaped?

disappeared for sure

left with a new version of me
grimy
street urchin
uncombed hair
repulsive

feeling disgusting
wanting to die

after all, i was already dead

separate bedrooms

meant separated lives
separation in the road that led to my future
separation of the beating heart that i once shared with
my father

now i was supposed to inhale and exhale by myself
whisper to the dark

who did i belong to?
where did he go?

afraid of the dark in my separate room

embers

i walk past the same white frame house with the screened
front porch every day for years

then one day i walk past and it is gone

i didn't see the fire but i know there was one
i see smoking embers, feel the heat in the air

the effects tell me what happened

same with sexual abuse
the fire that burned me down

the mirror

early years, my father's favorite
i saw myself as extra special, cherished

after the exile, the mirror showed me a short, plain,
brown-haired girl
hardly there
lifeless

i turned away

always present

it happened so long ago

i've tried putting it to sleep
i've tried shutting the lid on the box
i've tried closing the book it lives in

then i remember that when it's awake
when the lid is off the box
when the cover of the book is open

i feel
i'm full
i'm me

being

instead of wishing, wanting, thinking
just do it! Says NIKE

i can't, i won't, i'm afraid

i wish i could

i want to

i'm thinking about it

damaged goods

do the scars and bruises ever go away?
or are they badges of honor?
tattoos that mark me and let me never forget

catastrophizing

i go from fear to terror in 3 seconds

an old, learned response

somewhere way past panic
paralyzing
helpless

annE '2020

cry baby

cry baby cry
you're asleep in there
so deep in there

so sleep until you wake

and then cry baby cry

Doesn't Everyone?

My maternal grandmother's recipe for turkey stuffing
was handed down to her daughters.
Every Thanksgiving—the signature dish…

Spinach Stuffing for Turkey
2 cups chopped celery
2 cups chopped spinach
(chop celery and spinach together after measuring)
¾ to 1 cup grated cheddar cheese
2 to 2 ¼ cups cracker crumbs
8 eggs (9 if small)
1 Tsp olive oil to each egg + 1 extra
1 Tsp salt
1 heaping teaspoon poultry seasoning
(This amount is sufficient for a 16 lb. turkey)

When I was 19, friends from college stopped in
for a surprise visit on their way back to school over
Thanksgiving break.
Friends over. A rare occasion in my house.
I opened the refrigerator and took out leftovers to offer
them lunch.
"What's that?" one of them asked.
"Stuffing," I replied.
"GREEN?" she questioned. "Stuffing is always brown,"
all the friends agreed.

That was the first time I knew that all stuffing wasn't
green.

Did all little girls sleep with their fathers?

food 1

when all that matters is food
food is all that matters

it comforts me, quiets the voice in my head

stopped all feelings

it worked for so long, until it didn't

the feelings taste better than i thought they would

food ll

sometimes food is my lover
i'm a prisoner, an inmate
well disguised

food for thought

grocery store, refrigerator, pantry, menu, restaurant,
breakfast, lunch, dinner, snack

"don't get too hungry"
"don't get too full"
"here, have a cookie…you'll feel better"
"why did i eat that cookie?"

shhh…

annE '90

self

i want to hear you…it's just very difficult

grief

long periods without it
so long i would believe it wasn't a part of me any longer
and then she's back
with a vengeance

"how dare you forget me?" she shrieks
she has me by the throat
entering my mind with unimaginable twisting and turning
clouding every thought

where am i?
i'm in her clutches
i belong to her

she paralyzes me

and when she's gone
i try to remember i'm still me

lessen/lesson

now i don't want to believe i loved him, my father
thought that would lessen the collateral damage, me

what a lesson

don't speak

having been silent on the subject for decades, she
struggles with finding her voice

"don't cry"
"never write anything down"
"don't speak about things inside this house to anyone
outside this house"

don't speak about those inside this house that didn't
speak to one another

me to me

me: i'm sorry you're so sad
me: really? seems like you're always mad at me
me: i guess i am...and also, you're so sad
me: maybe we need couples counseling

Money

When my father arrived home from work, he routinely removed his tie and his suit jacket and placed it on the back of the same dining room chair each evening.
No lights were on in that unused room.

He then proceeded to sit in his red leather chair around the corner in the living room and watch tv.

In the year following our separation, I spent a few weeks sneaking into his inside suit coat pocket and removing his wallet.

My heart would pound. I was so afraid he would hear me or someone would see me.
I would remove a few bills and replace the wallet...
holding my breath the whole time.

The next day I would go to the little corner store across the street from school and spend it on penny candy for any kids who were present.

You steal from me—I'll steal from you.

Welcome to the Neighborhood

We moved into a brand-new house.
I was 17 and full of hope.
My mother had only lived in her parents' house her
whole life.
She was 56.
Things would be different in this house.
We would all be happy in our new house.

Is that happiness I see on my mother's face?
In her walk?

Brand new everything...her very own new appliances in
her new kitchen, new bookshelves for all her books.
Beautiful drapes flowing by the open window on this
summer night...first night home.

Sounds of the sprinkler on her new front lawn.
Two hours later, my father's rage.
Water is spraying through the open window, drenching
the silk, turning the drapes from a gentle champagne
color to dark mud.

"Go get the car!" he shouts.
I watch him pull the BB gun from the back of the
hallway closet.
Terrified to be his driver and more terrified to defy him,
I pull the car up as he runs out to the driveway.

He jumps in the passenger seat. We drive up and down
Franklin Avenue and Sycamore Street.

When we saw a teenager, he'd yell, "Stop!"
I tried to stare straight ahead but couldn't help glancing
to see him with the barrel of the gun out of his window
and see the terror on the face of a fellow classmate.
"Did you move that sprinkler?" he boomed.
Of course, the answer was always "no."

No one was shot, that night.

Off to College

For twelve years of school, I wore a shiny gaberdine
navy blue blazer, saddle shoes with white anklets and a
white blouse with a four-point collar.

The summer before college my aunt took me shopping.
My wonderful, New York City aunt.
She smoked cigarettes in a long black cigarette holder
with a silver tip, she swore and wore bright-colored shift
dresses from the pages of Vogue and Givenchy shoes.

I returned home with an orange pleated skirt and an
orange mohair sweater!
Also a beautiful sky blue and cranberry plaid skirt with a
cranberry sweater!

COLOR!

color in a dark, quiet house
color on my body!

"Show your father," my mother said.

I draped my body with orange,
I felt so proud, maybe he would like me again.
I entered the den, looking for the long lost connection.

As always, he was ensconced in his red leather chair,
newspaper in front of his face, cigarette burning in the
ashtray by his side.
"Look Bill," my mother said.

My father put down his newspaper, then threw his thick-lensed glasses to the floor.
They bounced three feet and hit the floorboard on the opposite wall.
He covered his face.

My mother pulled me from the room and said, "bright colors hurt your father's eyes."
Was that what hurt my father's eyes?
I knew the truth…I was too hard to look at.
I just didn't realize why.

The first week after I arrived in Colorado for college, I gave the orange mohair sweater, the orange pleated skirt, the cranberry sweater with the sky blue and cranberry plaid skirt away to a beautiful blond girl from Los Angeles.

For the rest of college, I wore dark-colored cords and baggy sweatshirts.

Comfortable
Invisible

so what

if thoughts stay in my head, they're safely tucked away
nobody hears them
nobody sees them
maybe they'll be forgotten

if i write them, there they are!
for anyone to see

people will "know" me
maybe contradict me
maybe call me a liar
maybe laugh at me

SEE me

SO WHAT???

That Bad

Was it really that bad?
He didn't come at me with a knife in his hand.
He didn't cover my mouth.

The truth is, I wanted him in the bed.

When would the 9:00 news be over?
When would I hear him unlock and relock the heavy
mahogany door?

I hear him walk up the massive staircase.
Seven carpeted stairs, the landing and then thirteen more,
his smoker's cough accompanying his assent.
At last I see the small red light of his Camel cigarette
enter the dark bedroom.
Always the same routine…carefully taking his gold
pocket watch and putting it in the top right drawer of his
bureau, setting his cufflinks into a small box on the front
of the mirrored chest, hanging up his tie and suitcoat,
removing his shoes and trousers, hanging them with their
perfect crease, detaching his socks from the garters on
his calves.

I wait patiently as he goes into the bathroom.

At last he is in his freshly ironed pajamas.

My head is on his chest.
Safe.

Until he reached for me.

the truth

what if my truth is ugly, disturbing?
what if decades ago my truth was sealed by a promise
never to tell?

what if i was responsible for seducing my father?
how do i speak that truth?

i promised him i never would tell

until

i thought i was awake…
until i woke up

will the truth set me free?

only if i can withstand it—

you already did withstand it
this is just "re-membering"

The Therapist

I was a young mother struggling with my four-year-old
child.
Her pediatrician recommended we see a therapist.
After one session, the therapist told me I should
continue seeing him alone.

I did. For a long time. He became all-powerful,
everything.
My life became even smaller and my dependency on him
greater.
Until I rarely left the house and if I picked up the phone,
it was only to call him.

During one session on a Tuesday afternoon, he pulled up
an empty wooden armchair and told me to imagine my
deceased father sitting in it.

After a few gut-wrenching minutes "speaking" to my
father, I started shaking and whispered,
"You were sexual with me!"
The therapist abruptly stood. "That's a terrible thing to
say about your father!"
I stared at my shoes. The session was over.

I shoved the memory back down where it had lived for
all those years.

Later, when I wanted to stop seeing the therapist (against
his wishes) I arrived one day in a beautiful white blouse
with a ruffle down the front and my favorite navy blue

wool coat. I stood face to face with him and said it was my last session. I was terrified to go out on my own.

"If you are really well," he said, "you'll be comfortable with me touching your breasts."

The message was clear to me: if I were not comfortable, I was sick.

If asked if he touched my breasts, I don't remember. I only remember his hand reaching under my navy blue coat, headed for my beautiful white blouse.

loyalty

i signed an unwritten document promising to belong to
my father
to be on his side and by his side no matter what

loyalty wasn't difficult
he was above anyone or anything
he was all and everything i needed

i was his and he was mine
such a wonderful secret

passing the time together
until i was "old enough" to leave

the thought of living alone with him in our "cabin in
the mountains of Colorado" was all i needed to tolerate
school, my siblings and my mother

i did everything i could to not "need a mother" and
prove i was ready to leave

whatever he needed
whatever he wanted

collateral damage

childhood sexual abuse lives on for generations
the abused child grows up and her children have a
wounded mother

she sees, hears, speaks, thinks, feels through the filter of
her wounds

she means no harm
she loves them with all she's got
it's just all she's got

First Confrontation with The Therapist

Flash forward to sober me. Three times divorced and
mother of three.
I called the therapist and made an appointment under my
new name.
I confronted him about his sexual abuse and told
him the even bigger damage was him discounting the
information about my father.
"I was trying to help you with your sexuality," he said.

To this day, I am surprised he admitted it.
Had he told me that I was crazy or called me a liar
I probably would have once again doubted my own
memory.

His response to my comment about my father was, "We
had no evidence."

"My words WERE the evidence!"

At the time, I believed he cost me two additional
divorces and 15 more years of drug and alcohol abuse.
Today I know of course that life unfolds as it should,
and in fact built a woman, an artist who trusts the stories
of my past.

imprints

we were going to Colorado, he and i

in my head, i was already in Colorado during the
depressing, silent dinner at the formica kitchen table
my asthmatic brother struggling to breathe
my mother standing at the sink reading one of her
library books
the plastic cover full of her fingerprints
my sister hiding in her room

i waited for, "let's go for a ride"
he and i alone in the car, eating Krackel bars,
driving up and down the streets "looking at houses"
getting ideas for our Colorado cabin
"do you like that front porch?" "what do you think of
that color?" he would ask

where did i go to college?
Colorado
what did i do for a living?
show people houses

and always chocolate was comfort

misunderstanding

i mistook her as the enemy within
i didn't recognize her as my savior
my childhood warrior coming to the rescue

she's never left my side, even with how hard i've tried to
get rid of her

how valiant she's been

instead of trying to annihilate her, i need to tell her she's
welcome here

hide and seek

i'm a master of hiding places

"don't find me," i say to life

life has other ideas

it's sometimes painful when i'm found
life shines a light on me and i look around
how did i get here?

why did i think this place was better than being with life?

often it's glorious when life finds me
i rejoice that i am released

i vow to play with life forever

until i play hide and seek again

Second Confrontation with The Therapist

Years later, rollerblading along on a perfect, sunny,
75-degree Saturday with the voice of Neil Young filling
my headphones, I spotted him.
The therapist, amid tourists on the boardwalk, hobbling
along with his wife.
He had polio as a child and walked with a limp in his left
leg, always leaning on a cane.
I sped past him on my skates, made a perfect turn, and
raced back to him.
My rubber brake scraped as I stopped inches from his
face.
"I want you to know I survived you!"

His wife opened her mouth and paused.
I turned and pushed forward, "Who's that?" I heard her
say as I glided toward the volleyball players in the sand
on the beach.

clarity

i'm ready to throw off the down comforter of the
fantasy story
with which i've comforted myself for decades

it's time

it's proving to be a relief--powerful, shocking, and painful

sorry for myself

how excruciating it felt to exist
i would say, "stop feeling sorry for yourself"

i stopped feeling

memory

memory
it dodges in and out of shadows
it's quiet until it's not

can't decide which is worse
not remembering or remembering

not true!
remembering is always better

once upon a time

once upon a time there was a princess who wasn't

she had been given a potion and was under a spell
although a bit foggy, she performed her princess duties
faithfully

until she was exiled
(the queen took care of that)

alone, she awakened to find herself in a dark place called
Reality
Reality being a wicked foe
so she embraced a new magic potion
denial

as she grew older, she cleverly found even more potions
and spirits that lifted her Spirit

until they didn't

eventually she found the gift of Self
what a lovely reunion
there has been much celebration since that day
including the awareness of the CHARMed life she enjoys
she is truly a **C**hild **H**ealing as an **A**dult **R**ecovering from
Molestation

Final Confrontation with The Therapist

A year or two after I saw him on my rollerblades, I saw him again in a crowded Border's bookstore around 5:00 one evening.
I stopped and glared at him.

Cane in hand, he purposefully made his way over to me and said, "I just want you to know I only did what you wanted me to do."

"Doctor, even if I had taken off all my clothes, laid down on your couch, and begged you…your actions were criminal!"

Out of the corner of my eye, I saw a young woman in a red knit hat jerk her head around as I walked away.

Free Parking

A street named for a pedophile, my father.
Unacceptable.

On a mission, I met with the president of the village, a
board member, the village attorney, and the pastor of the
local church.
All men.

I took them on one at a time…looking in each man's
eyes, saying,
"I don't know if I am speaking to a pedophile right
now."
Paused a moment and then went on…
"My father sexually abused me when I was young.
I am outraged that a street is named after him."

I felt calm, strong.
I sensed that each man was more uncomfortable than I
was.

Perhaps not true for the pastor who immediately
proclaimed his support.
"I have never engaged in any issues with the town
before," he said.
"In this instance," he went on, "I am more than happy to
get involved.
Too many Sundays I have stood in the pulpit and looked
down at children who have been sexually abused sitting
next to their abuser."

Weeks later, the president of the board asked me to meet him at a local Starbucks and apologetically told me that the board had rejected my request.

"As sorry as they are for what happened to you, they feel that your father did a good job as a village official," he told me while drinking his latte.

I never really thought they would change the street name. I had gone to "tell" on my father.

The board president slid his cup left to right a few times, stammered a bit, lowered his head, and sheepishly said, "We voted to offer you free parking for the rest of your life."

I stood, felt the sunlight on my face, looked down at him, laughed, and took myself home.

The Shooting

Decades after the abuse and years after my remembering it, I was cleaning out my basement and found a beat-up cardboard box that I had retrieved from my mother's house after she died.
I knew it was full of old photos, mostly black and whites, but had never had the time or the desire to go through it. Alone in my house, I set the large box on the wooden kitchen floor.
I peeled off the weathered dried tape that was barely holding it closed and leaned over to see a matte finish, 8x10 black and white photo of my dead father staring up at me.

I froze.
He was bigger than life.
In his three-piece suit.
Full of power.
I knew I had to destroy his photo.
Destroy it in a meaningful way.
Tearing it to pieces would not be enough.
Burning it would be too fast.
I decided to murder it.
Shoot it to death.

I had never held a gun before.

I took my time searching for the right person, a safe person to help with my plan.

I went to a shooting range and practiced holding, aiming,

and pulling the trigger, occasionally hitting the paper target that was 30 feet away.
I went week after week, improving each time.
I applied for and received a firearms license.
Not necessary, but obtaining the license felt important and official to me.

Eventually I taped the photo of my pedophile father onto the paper target, sent it out, and began killing the photo.
I felt some power over him now.
Separate.
In charge.
At first I was able to hit the photo in his chest, then his arm and in a subsequent visit to the range I was able to zero in on his crotch.
There was nothing left of that part of the photo when I was done with that session.
It took a couple more visits for me to erase his face.

When I was finally satisfied, I took the withered, shredded paper to the cemetery and taped it to my father's headstone that lay flat on the ground.
When I went back a few weeks later, I expected it to be gone due to weather conditions or groundskeepers.
Amazingly, it was still taped to the stone that named him and gave his date of birth and death.

That same day, I plunged a butcher knife into the grass covering his casket.

I left layers of pain at the cemetery that day.
When I opened my mouth and wailed, a flock of geese leapt into the sky.

today

today she leads a CHARMed life in spite of it all (due to it all?)

because of the damage to her body, she had to find a way to heal her soul

because of being blinded to truth, she had to find a new way to see

because of being deafened by lies, she had to find a new way to hear

because of being muted, she had to find this new voice

compliance

the research:
a) a child cannot be compliant in matters of sexual
behavior with an adult
b) a girl cannot be compliant in matters of sexual
behavior with a man
c) a daughter cannot be compliant in matters of sexual
behavior with her father

the problem:
getting her to believe that

forgiveness

i am profoundly sorry that it has taken me this long

despite crowded shelves of self-help books, numerous
mentors, therapists galore, and Oprah,
it has taken me this long

with self-awareness and more self-awareness and then
more self-awareness,
it has taken me this long

i forgive you for what never needed forgiving

you played no part in his crime

amnesia

can't remember
won't remember

there's nothing to remember

and then...there it is

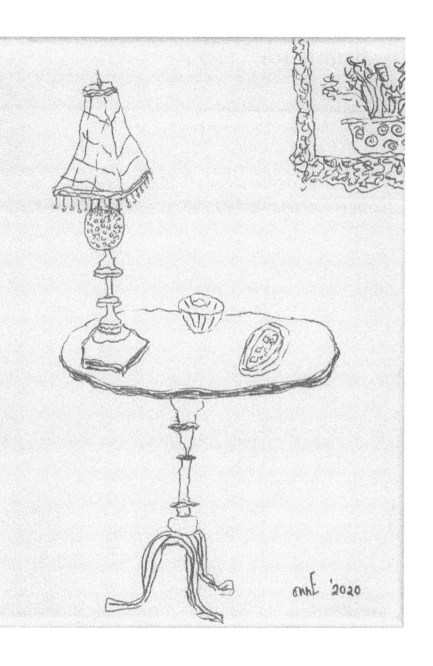

anne '2020

dear truth

why are you so relentless?
must you constantly distract me?
can't you just be quiet?

i'm out with friends having a lovely dinner and there you
are making me remember what my body felt like in his
bed

breath

comes and goes
breathe it in
breathe it out
cherish it
make it yours
make it you

feel safe in the calmness
feel safe in your breath
feel safe

good

i am a good woman
who finally believes that i have always been a good girl

Hard Earned Skills

My father bought a new car every two years. It was a grey Cadillac.
Always a four-door, grey leather interior, big as a boat.
He bought the same color and similar model so no one would notice.

My mother and my siblings were forbidden to tell anyone that we had a new car.

We were the first ones in the neighborhood to get a color tv. It was a big console with a giant antenna. Again, we were forbidden to tell anyone.

Why couldn't we celebrate the joy of something new?
Learned to keep secrets from a very young age.

I learned how to not ignite his temper.
I learned how to deal with difficult people.
I apologize when an apology is not necessary, act like I like someone when I feel afraid of them.

I read people's moods, get out of the way, or de-escalate situations.
I feel no fear and anger.

What I didn't realize was that the same button I used to turn off fear, anger and loneliness shut off joy, love and satisfaction.

integration

explosive, painful, terrifying
healing

re-membering

now when i am re-membering i remind myself that i am
just remembering
remind myself that it's a part of me, not the whole me
too often the grief of that time takes over and i'm
unable to understand that it's not
happening now, again, always

i put on a mask and a costume as I have for so many
years and cover myself with an acceptable, functioning
pretense so the darkness doesn't show
the college girl at parties, room mother at school,
costumes for work, and wife
walking around in the dark, bumping into things

unchangeable past

would i have it any other way?
change one thing that would change all things?

then where, what, who would i be?

would i like that unrecognizable me more than i like this
me?

women in my life

i am angry
i am furious
my soul is on fire
i walk through memory and burn it down

to my mother i say
"how dare you not get him out of the house?!!"
pick me up and run and run until we became invisible,
no way for him to find me
"i should have separated you two long before i did" were
your last words to me

to my aunt I say
"did you know?"
i trusted you

my sister told me "you can't talk about this…don't you
understand he maimed me too?"
i say, "goodbye"

watch out all the women who have silenced me, shamed
me and covered me up

i dress for battle now

writing

she's a dance partner
seductive
cruel at times

glorious when we are one, gliding around the room

and then she's gone...

so often i'm unwilling to hear her melody

i can't dance
i won't dance

i must dance

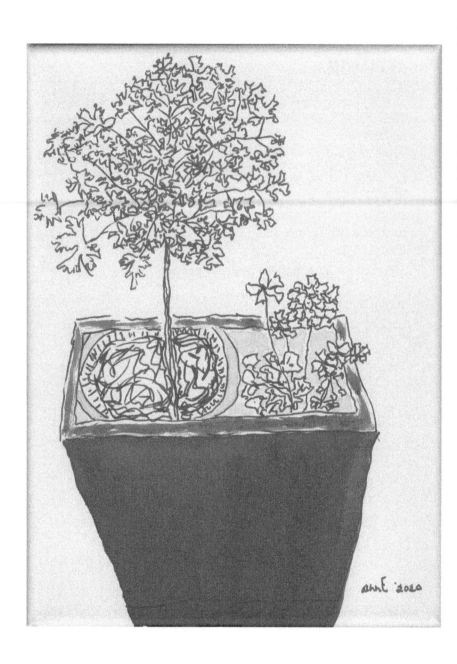

yes

yes i am a survivor of childhood sexual abuse
i am also a victim of childhood sexual abuse

yes i am a victim of childhood sexual abuse
i am also a survivor of childhood sexual abuse

their deaths

two nights before she slipped into a coma
two weeks before she left the world
my mother said to me, "you know your father really did
love you"
my response. "that was before you broke us apart"
(at that time i had not remembered the abuse)
"i should have done it long before i did," she whispered,
wiping her eyes

years earlier my father slipped into a coma
my brother, mother and i stood by his bed in the
emergency room
we watched as the lack of oxygen affected his brain
his eyes were wild
he frantically babbled the Hail Mary faster than i've
heard anyone speak

as he masturbated

Cheers

Walking home from the grocery store, beautiful night, dusk.
A tall, slim person bouncing along toward me wearing baggy pants and gleaming white NIKEs.
Ducking their head under a tree branch.
I heard a cheerful "cheers" although I couldn't really see in the fading light.
"Cheers!" I returned.

Then two steps later, close enough to see each other's faces, I heard, "Sorry, but I just don't like old white women."

Me? When had that happened???

I've been a grandmother for 20 years, a mother for 50.
I've celebrated 72 birthdays (many of which I don't remember).

The person saw an old white woman.

They missed the struggling female diligently working to improve her self-acceptance.
The young woman who entered into motherhood while still a confused girl.
The drug addict filled with self-loathing.
The schoolgirl unable to concentrate.
The divorced wife of three men, each more abusive than the last.

The artist (could I show them my paintings?).
The awakened spirit who found recovery.

The little child who adored her father—whose duty it was
to be his sidekick, his companion, who shared his bed.

A giant secret for a small girl.

Not just an old white woman.

The Play

Spent over two decades in therapy, reading dozens of books on the subject, working hard to believe I had no fault in the sexual abuse of my childhood.
It worked for periods of time, certainly I knew the truth intellectually.
The problem was knowing it in my soul, in my being.
I could cover up the shame but was never able to expunge* it from my identity.

expunge
Verb
Erase or remove completely (something unwanted or unpleasant)

UNTIL 2018 when I went alone to see a friend in a play called "How I Learned to Drive"
written by Paula Vogel

"The story follows the strained, sexual relationship between Li'l Bit and her aunt's husband from her pre-adolescence through her teenage years and beyond. Using the metaphor of driving and the issues of pedophilia, incest, and misogyny, the play explores the ideas of control and manipulation."

In a small offbeat theater, I sat on the aisle seat in the front row…level with the actors.
As I watched my friend, I saw her become a young girl sexually abused by her "loving" uncle.
I was able to see him as the pedophile he was.

I knew Li'l Bit was innocent.
I finally knew my truth.

My responsibility was expunged.

The Wizard of Us

When he reached for me in bed, I floated out of my
body and over to the radiator, felt its strong presence,
heard its gentle hissing, gazed at the gauzy curtains
above.
In the warm weather, the curtains would dance if there
was a breeze and the radiator stood silent and strong.

I would find such comfort from these inanimate
friends…these beautiful distractions.
To this day, whenever I pass a radiator, I touch it with
thanks.

During the day I felt like a princess.
Beloved.
I loved him so much.
I tolerated the time when he was at work and rejoiced
when he walked in the door calling, "Where's Baby?"
Our secret plans for the future, our nightly car rides,
our sharing Krackel bars and codeine cough syrup…all
added up to what I thought was love, security, and safety.

If my school had a day off, I went to work with my
father…had no interest in playing outside or staying
home.
I felt so grown up and special, putting on good shoes,
white anklets and a nice dress, riding the train into the
city by his side.

He was important, so I felt important.

Only in my recovery years have I been able to pull back the curtain like Dorothy did and see a frightened and flawed man.

Like Dorothy's friends, I have courage, a clear brain, and a loving heart.

Artist Statement

annEpeck is a Chicago artist and a true believer in the wonderful world of color and creativity...
annE has always been a lover of art and began painting as a way to express herself in a unique and whimsical way
Having to put her love of painting on hold for many years
in order to live life "on life's terms," she has found a way to live and paint on her own terms.
annE has studied at the School of the Art Institute of Chicago and continues to learn and grow
in both her creativity and appreciation of the many colors of life...

"when i am not afraid of the uncertainty of life, it turns into magic...
and then i am able to paint...and i am wide awake"

art

she's right there in my heART
i look at the easel, the colors, the brushes

pick up the brush and stART

Another Theater, Another Movie

The movie is SPOTLIGHT
about the coverup of sexual abuse by priests in the
Catholic Church

Catholic priests sexually abusing young boys and girls
criminal
horrific
unthinkable
vile

THE CATHOLIC CHURCH COVERING UP THE
ABUSE BY PRIESTS!!!
CRIMINAL! HORRIFIC! UNTHINKABLE!
VILE!

Transferring them, reassigning them

Crime #1 the abuse
Crime #2 the coverup

The responsible and diligent reporters from the Boston
Globe uncovered the coverup
Applause!! Applause!! Applause!!

They could not undo the abuse
Just MAYBE, by shining their spotlight, some of the
victims might be able to come out of the darkness and
PERHAPS begin to heal

The support group SNAP was mentioned in the movie
Support Network of those Abused by Priests

I walked out of the movie feeling anger, gratitude and hope

I sat on the green cushioned bench by the door marked EXIT
I wished that my abuse had been by a priest
Then I would have a support group to attend

When I later told that to a friend, she said, "why don't you start something of your own?"

A few days later, I was on a walk trying out different words that could build an acronym for what had happened to me

CHARM presented itself
Children Healing as Adults from Molestation

Charm---a beautiful, soft word
Children **H**ealing as **A**dults **R**ecovering from **M**olestation CAN lead a CHARMed life!

CHARM, a gift I received on that walk

My own spotlight on childhood sexual abuse

Childhood sexual abuse grows in the dark

Conversation, education and prevention are our weapons
Time to talk about childhood sexual abuse

"The more we don't talk about it, the more it will continue."
-Common

After the Walk

The word *charm* took on a new meaning for me.
It told a story, that one small word.

I wanted it to take on new meaning to others.
I wanted to hold it in my hand.

Alive with its new meaning, I registered at the United
States Patent and Trademark Office.

CHARM® which then gave birth to charmgroup.org, a
place where any adult who has experienced childhood
sexual abuse can come to heal.

When I received the certificate, I held it in my hand,
framed it, and hung it on my wall.
Proof we can all lead a CHARMed life, no matter our
past

.

United States of America

United States Patent and Trademark Office

CHARM

Int. Cl.: 35

Service Mark

Principal Register

CLASS 35: Promoting public awareness of survivors of childhood sexual abuse

FIRST USE 8-30-2017; IN COMMERCE 8-30-2017

THE MARK CONSISTS OF STANDARD CHARACTERS WITHOUT CLAIM TO ANY PARTICULAR FONT STYLE, SIZE OR COLOR

SER. NO. 86-928,536, FILED 03-03-2016

Joseph Matol

Performing the Functions and Duties of the
Under Secretary of Commerce for
Intellectual Property and Director of the
United States Patent and Trademark Office

wishing you from this moment
forward a CHARMed life